THRILL-MAD
PUSSYCATS

PULP POSTCARDS

PRION

First published in 2000 by
Prion Books Limited
Imperial Works
Perren Street
London NW5 3ED
www.prionbooks.com

Compilation © Prion Books
Images Copyright © Jeffrey Luther / PC Design
www.pulpcards.com
All rights reserved

ISBN 1-85375-394-7

Printed and bound in China
by Leo Paper Products Ltd

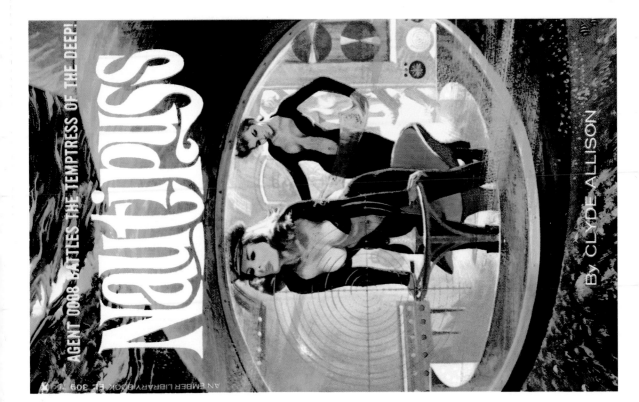

AGENT 0008 BATTLES THE TEMPTRESS OF THE DEEP!

Nautipuss

BY CLYDE ALLISON

AN EMBER LIBRARY BOOK EL 309 75¢

PULP POSTCARDS

THRILL-MAD PUSSYCATS

Prion Books Ltd. Imperial Works, Perren Street, London NW5 3ED www.prionbooks.com

The temptress of the deep!

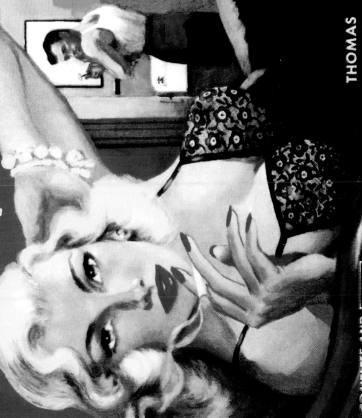

18

K

THE SCANDALOUS STORY OF A THRILL-MAD PLAYGIRL

Shameless Honeymoon

PB PYRAMID BOOKS

THOMAS STONE

COMPLETE AND UNABRIDGED

25¢

PULP POSTCARDS

THRILL-MAD PUSSYCATS

Prion Books Ltd. Imperial Works, Perren Street, London NW5 3ED www.prionbooks.com

The scandalous story of a thrill-mad playgirl.

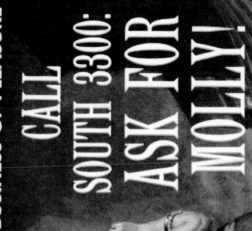

SHE MADE A BUSINESS OF PLEASURE

CALL
SOUTH 3300:
ASK FOR
MOLLY!

by Orrie Hitt

A CANDID NOVEL THAT
TAKES YOU BEHIND
THE SCENES AT THOSE
SALES CONVENTIONS!

B176
35¢
K

PULP POSTCARDS

THRILL-MAD PUSSYCATS

Prion Books Ltd. Imperial Works, Perren Street, London NW5 3ED www.prionbooks.com

She made a business of pleasure.

35¢

A SPICY, RACY TALE OF BROADWAY—
by the author of "LET'S MAKE MARY"

Tomcat in Tights

JACK HANLEY

THE ORIGINAL NOVEL 27

AHC

PULP POSTCARDS

THRILL-MAD PUSSYCATS

Prion Books Ltd. Imperial Works, Perren Street, London NW5 3ED **www.prionbooks.com**

Tomcat in tights.

PULP POSTCARDS

THRILL-MAD PUSSYCATS

Prion Books Ltd. Imperial Works, Perren Street, London NW5 3ED www.prionbooks.com

Wanted – someone to give me my special kind of love.

GLORIA — MADELINE — SANDY!
EACH WAS EASY PICKIN'S

PUSHOVER

by Orrie Hitt

35¢
B 380

THE TORRID TALE
OF A TOWN MORE
WICKED THAN
PEYTON PLACE!

PULP POSTCARDS

THRILL-MAD PUSSYCATS

Prion Books Ltd. Imperial Works, Perren Street, London NW5 3ED **www.prionbooks.com**

Easy Pickin's pushover.

Plaything of Passion

2/6D

PRICE IN U.S.A. 35¢ AND CANADA

AN ARCHER BOOK

Mad, unholy desire, strange diabolical hate and an all-consuming love reveals itself in this novel.

JEANETTE REVÉRE

PULP POSTCARDS

THRILL-MAD PUSSYCATS

Prion Books Ltd. Imperial Works, Perren Street, London NW5 3ED www.prionbooks.com

Plaything of passion.

PULP POSTCARDS

THRILL-MAD PUSSYCATS

Prion Books Ltd. Imperial Works, Perren Street, London NW5 3ED www.prionbooks.com

Coffin for a cutie.

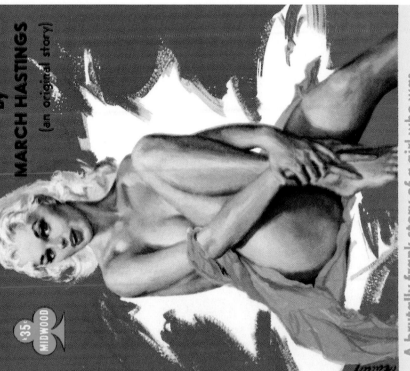

She just didn't know how to say no to a man.
That's why she was

ANYBODY'S GIRL

By
MARCH HASTINGS
(an original story)

35¢ MIDWOOD

PULP POSTCARDS

THRILL-MAD PUSSYCATS

Prion Books Ltd. Imperial Works, Perren Street, London NW5 3ED **www.prionbooks.com**

She just didn't know how to say no to a man.

She wanted a man just like her sister had — so she took him

LIKE WILD

Eric Allen

First Publication Anywhere

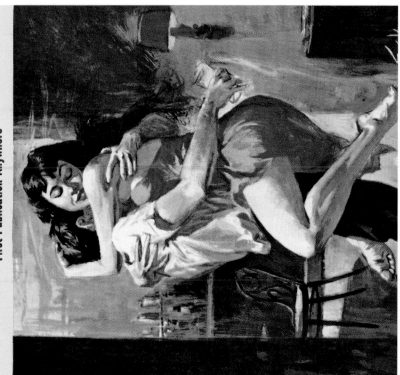

PULP POSTCARDS

THRILL-MAD PUSSYCATS

Prion Books Ltd. Imperial Works, Perren Street, London NW5 3ED **www.prionbooks.com**

She wanted a man just like her sister had – so she took him.

WHY DID SHE OFFER HERSELF—*to any man?*

7

HOT DATE

(SHAME GIRL)

ELLIOT STORM

PULP POSTCARDS

THRILL-MAD PUSSYCATS

Prion Books Ltd. Imperial Works, Perren Street, London NW5 3ED www.prionbooks.com

Why did she offer herself – <u>to any man</u>?

PDC

THE VIRGIN
and the BARFLY

By *Gerald Foster*
Author of VERA IS A TRAMP

THERE'S ONLY ONE WAY FOR A GORGEOUS
GAL WITHOUT MONEY TO PAY A DEBT!

25¢

QUARTER BOOKS

PULP POSTCARDS

THRILL-MAD PUSSYCATS

Prion Books Ltd. Imperial Works, Perren Street, London NW5 3ED **www.prionbooks.com**

*There's only one way for a gorgeous gal without money
to pay a debt.*

PULP POSTCARDS

THRILL-MAD PUSSYCATS

Prion Books Ltd. Imperial Works, Perren Street, London NW5 3ED www.prionbooks.com

Her candle burns hot!

QUICKIE!

OH, WHAT A GAL WAS QUICKIE!

PDC

25¢ QUARTER BOOKS

By *Gerald Foster*

Author of the Unforgettable
Best Seller
ROOM AND DAME

AN ILLUSTRATED BOOK

PULP POSTCARDS

THRILL-MAD PUSSYCATS

Prion Books Ltd. Imperial Works, Perren Street, London NW5 3ED www.prionbooks.com

Oh, what a gal was Quickie!

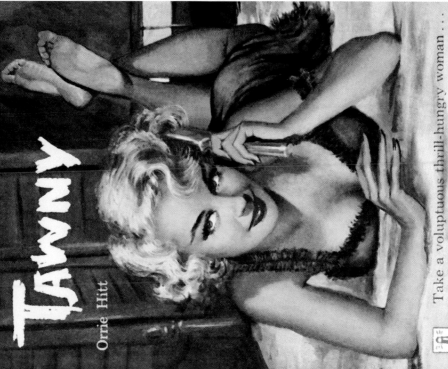

SHE WAS A CHEAP TRAMP,
BUT SHE WAS A LUSCIOUS WOMAN . . .
AND HE WANTED HER!

Tawny

Orrie Hitt

Take a voluptuous thrill-hungry woman . . .
add one summer resort Casanova — throw
in a weakling of a husband — and you
have the ingredients for one of
Orrie Hitt's spiciest yarns!

PULP POSTCARDS

THRILL-MAD PUSSYCATS

Prion Books Ltd. Imperial Works, Perren Street, London NW5 3ED www.prionbooks.com

She was a cheap tramp, but she was a luscious woman...
and he wanted her!

Play Rough!

RAINBOW No. 113

A BRAND
NEW NOVEL BY
RICK WAYNE

A SENSATIONAL
NOVEL OF A RAT
WHO WANTED A
WOMAN—TO SHARE
WITH HIS
UNDERWORLD RIVALS!

THRILL-MAD PUSSYCATS

Prion Books Ltd. Imperial Works, Perren Street, London NW5 3ED **www.prionbooks.com**

A rat who wanted a woman – to share.

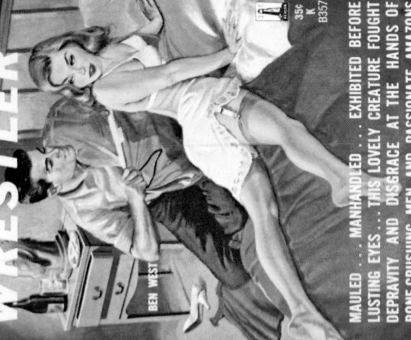

A TERROR IN THE RING.... A TIGRESS IN THE BOUDOIR!

LOVES OF A
**GIRL
WRESTLER**

BEN WEST

35¢
K
B357

MAULED...MANHANDLED...EXHIBITED BEFORE LUSTING EYES...THIS LOVELY CREATURE FOUGHT DEPRAVITY AND DISGRACE AT THE HANDS OF BONE-CRUSHING MEN AND PASSIONATE AMAZONS

PULP POSTCARDS

THRILL-MAD PUSSYCATS

Prion Books Ltd. Imperial Works, Perren Street, London NW5 3ED **www.prionbooks.com**

A terror in the ring...a tigress in the boudoir.

PULP POSTCARDS

THRILL-MAD PUSSYCATS

Prion Books Ltd. Imperial Works, Perren Street, London NW5 3ED **www.prionbooks.com**

Divorce bait!

WHEN A ONE-MAN WOMAN PLAYS THE FIELD . . .

A brand new, unexpurgated novel
By *David Charlson*

No Time For MARRIAGE

VENUS BOOKS
No. 119 35¢
ANC

PULP POSTCARDS

www.prionbooks.com

THRILL-MAD PUSSYCATS

Prion Books Ltd. Imperial Works, Perren Street, London NW5 3ED

When a one-man woman plays the field.

RENO TRAMP

BY FLORENCE STONEBRAKER

Author of FLIRTING EYES · FLESH IS WEAK

SHE GAVE HER CHARMS TO THE HIGHEST BIDDER

A RAINBOW ROMANCE · 35¢ · No. 102

PDC

PULP POSTCARDS

THRILL-MAD PUSSYCATS

Prion Books Ltd. Imperial Works, Perren Street, London NW5 3ED www.prionbooks.com

She gave her charms to the highest bidder.

FAST, LOOSE AND LOVELY

A BRAND-NEW NOVEL

By Norman Bligh

Author of BED-TIME ANGEL

LET LOVE COME FIRST, LAST AND ALWAYS!

QUARTER BOOKS

PDC

PULP POSTCARDS

THRILL-MAD PUSSYCATS

Prion Books Ltd. Imperial Works, Perren Street, London NW5 3ED www.prionbooks.com

Fast, loose and lovely.

MAKE ME AN OFFER

CHARLES GORHAM

BERKLEY
BOOKS
G-199
35c

COMPLETE
AND
UNABRIDGED

Originally published as
THE GILDED HEARSE

PULP POSTCARDS

THRILL-MAD PUSSYCATS

Prion Books Ltd. Imperial Works, Perren Street, London NW5 3ED **www.prionbooks.com**

Make me an offer.

95c

PIT STOP NYMPHO

By Peter Kevin

ADULTS ONLY

Into the high tension world of Gran Prix racing roars jealous passions, red-hot lust and the ugly demon called homicide!

AN ORIGINAL IMPERIAL BOOK

PULP POSTCARDS

THRILL-MAD PUSSYCATS

Prion Books Ltd. Imperial Works, Perren Street, London NW5 3ED www.prionbooks.com

Pit stop nympho.

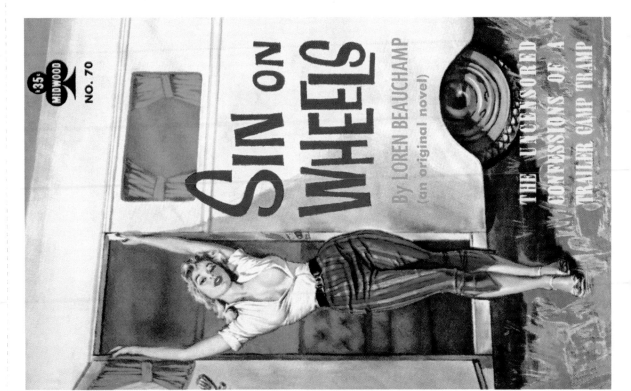

35¢ MIDWOOD NO. 70

SIN ON WHEELS

By LOREN BEAUCHAMP
(an original novel)

THE UNCENSORED CONFESSIONS OF A TRAILER CAMP TRAMP

PULP POSTCARDS

THRILL-MAD PUS3YCATS

Prion Books Ltd. Imperial Works, Perren Street, London NW5 3ED **www.prionbooks.com**

The uncensored confessions of a trailer camp tramp.

(EVE IN THE GARDEN)

Marriage Can Wait

By *James Clayford* Author of SINFUL!

25¢ QUARTER BOOKS

YOUTH IS THE TIME FOR LOVE AND FUN . . .

PULP POSTCARDS

THRILL-MAD PUSSYCATS

Prion Books Ltd. Imperial Works, Perren Street, London NW5 3ED www.prionbooks.com

Youth is the time for love and fun...

35¢

MAN
BAIT

He was a wolf
in the
asphalt jungle,
fair game
for a tigress
on the prowl.

JACK LISTON

Maguire

DELL

FIRST
EDITION

B158

PULP POSTCARDS

THRILL-MAD PUSSYCATS

Prion Books Ltd. Imperial Works, Perren Street, London NW5 3ED www.prionbooks.com

He was a wolf in the asphalt jungle, fair game for a tigress on the prowl.

She sang for her supper,
but did something else
for her midnight snack.

The HOT CANARY

By JOAN ELLIS

K 50¢ MIDWOOD

F238

FIRST PRINTING ANYWHERE

PULP POSTCARDS

THRILL-MAD PUSSYCATS

Prion Books Ltd. Imperial Works, Perren Street, London NW5 3ED www.prionbooks.com

She sang for her supper, but did something else for her midnight snack.

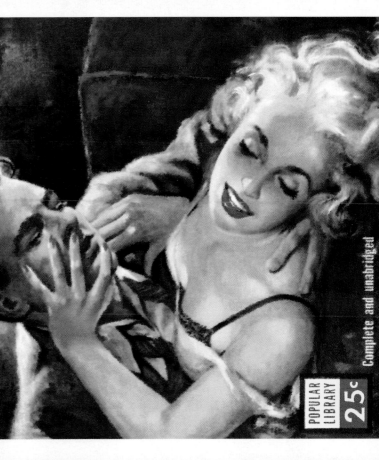

POPULAR LIBRARY

1469

Kay Conquered Hollywood Man By Man

HARD TO GET

(THE SQUIRREL CAGE)

Edwin Gilbert

Complete and unabridged

POPULAR LIBRARY
25c

PULP POSTCARDS

THRILL-MAD PUSSYCATS

Prion Books Ltd. Imperial Works, Perren Street, London NW5 3ED **www.prionbooks.com**

Hard to get.

CONFESSIONS OF AN EXECUTIVE SWEET

Office Tramp

Her Job was to Keep the Bosses Happy, and It Wasn't by Taking Dictation!

By SIDNEY PORCELAIN

K
50¢
MIDWOOD
NO. F152

PULP POSTCARDS

THRILL-MAD PUSSYCATS

Prion Books Ltd. Imperial Works, Perren Street, London NW5 3ED www.prionbooks.com

Office Tramp.

35c

SHE TRIED TO BE GOOD

BUS STOP

A BRAND NEW NOVEL BY

Florence Stonebraker

No. 133

THE AMAZING STORY OF CARRIE—DAUGHTER OF SIN

VENUS BOOKS

PULP POSTCARDS

THRILL-MAD PUSSYCATS

Prion Books Ltd. Imperial Works, Perren Street, London NW5 3ED www.prionbooks.com

She tried to be good.

EVERYBODY LOVES A LOOKER

By
...ght Williams

Author of
EXCESS WIFE
LUST FOR LOVE

AN ILLUSTRATED BOOK

25¢
QUARTER
BOOKS

THRILL-MAD PUSSYCATS

Prion Books Ltd. Imperial Works, Perren Street, London NW5 3ED **www.prionbooks.com**

Everybody loves a looker.